Angel Babies III

ANGEL BABIES III

Age Of Enlightenment

BY

CLIVE ALANDO TAYLOR

authorHOUSE®

AuthorHouse™ UK Ltd.
1663 Liberty Drive
Bloomington, IN 47403 USA
www.authorhouse.co.uk
Phone: 0800.197.4150

Published by AuthorHouse 02/03/2014

ISBN: 978-1-4918-9377-7 (sc)
ISBN: 978-1-4918-9378-4 (e)

EMERALD GREEN

PROLOGUE:
Revelations 4 Johns Vision.

After these things I looked and behold a door standing open in Heaven and the first voice which I heard was like a (Trumpet!) speaking with me saying come up here and I will show you things which must take place after this.

Immediately I was in the spirit and behold a throne set in Heaven and one sat on the throne and he who sat there was like a Jasper and a Sardius Stone in appearance, and there was a Rainbow around, in appearance like an Emerald.

The Angel Babies Age Of Enlightenment III
Angelus Domini

I N S P I R I T * A S P I R E * E S P R I T * I N S P I R E

Because of the things that have first become proclaimed within the spirit, and then translated in the soul, in order for the body to then become alive and responsive or to aspire, or to be inspired, if only then for the body to become a vessel, or a catalyst, or indeed an instrument of will, with which first the living spirit that gave life to it, along with the merits and the meaning of life, and the instruction and the interpretation of life, is simply to understand that the relationship between the spirit and the soul, are also the one living embodiment with which all things are one, and become connected and interwoven by creating, or causing what we can come to call, or refer to as the essence, or the cradle, or the fabric of life, which is in itself part physical and part spirit.

And so it is, that we are all brought in being, along with this primordial and spiritual birth, and along with this the presence or the origins of the spirit, which is also the fabric and the nurturer of the soul with which the body can be formed, albeit that by human standards, this act of nature however natural, can now take place through the act of procreation or consummation, and so it is with regard to this living spirit that we are also upon our natural and physical birth, given a name and a number, inasmuch that we represent, or become identified by a color, or upon our created formation and distinction of identity, we become recognized by our individuality.

But concerning the Angels, it has always been of an interest to me how their very conception, or existence, or origin from nature and

imagination, could have become formed and brought into being, as overtime I have heard several stories of how with the event of the first creation of man, that upon this event, that all the Angels were made to accept and to serve in God's creation of man, and that man was permitted to give command to these Angels in the event of his life, and the trials of his life which were to be mastered, but within this godly decree and narrative, we also see that there was all but one Angel that either disagreed or disapproved with, not only the creation of man, but also with the formation of this covenant between God and man, and that all but one Angel was Satan, who was somewhat displeased with God's creation of man, and in by doing so would not succumb or show respect or demonstrate servility or humility toward man or mankind.

As overtime it was also revealed to me, that with the creation of the Angels, that it was also much to their advantage as it was to ours, for the Angels themselves to adhere to this role and to serve in the best interest of man's endeavors upon the face of the earth, as long as man himself could demonstrate and become of a will and a nature to practice his faith with a spirit, and a soul, and a body that would become attuned to a godly or godlike nature, and in by doing so, and in by believing so, that all of his needs would be met with accordingly.

And so this perspective brings me to question my own faith and ideas about the concept and the ideology of Angels, insomuch so that I needed to address and to explore my own minds revelation, and to investigate that which I was told or at least that which I thought I knew concerning the Angels along with the juxtaposition that if Satan along with those Angels opposed to serving God's creation of man, and of those that did indeed seek to serve and to favor God's creation and to meet with the merits, and the dreams, and the aspirations of man, that could indeed cause us all to be at the mercy and the subjection of an externally influential and internal spiritual struggle or spiritual warfare, not only with ourselves, but also with our primordial and spiritual identity.

And also because of our own conceptual reasoning and comprehension beyond this event, is that we almost find ourselves astonished into believing that this idea of rights over our mortal souls or being, must have begun or started long ago, or at least long before any of us were even souls inhabiting our physical bodies here as a living presence upon the face of the earth, and such is this constructed dilemma behind our beliefs or identities, or the fact that the names, or the numbers that we have all been given, or that have at least become assigned to us, is simply because of the fact that we have all been born into the physical world.

As even I in my attempts, to try to come to terms with the very idea of how nature and creation could allow so many of us to question this reason of totality, if only for me to present to you the story of the Angel Babies, if only to understand, or to restore if your faith along with mine, back into the realms of mankind and humanity, as I have also come to reflect in my own approach and understanding of this narrative between God and Satan and the Angels, that also in recognizing that they all have the power to influence and to subject us to, as well as to direct mankind and humanity, either to our best or worst possibilities, if only then to challenge our primordial spiritual origin within the confines of our own lifestyles, and practices and beliefs, as if in our own efforts and practices that we are all each and every one of us, in subjection or at least examples and products of both good and bad influences.

Which is also why that in our spiritual nature, that we often call out to these heavenly and external Angelic forces to approach us, and to heal us, and to bless us spiritually, which is, or has to be made to become a necessity, especially when there is a humane need for us to call out for the assistance, and the welfare, and the benefit of our own souls, and our own bodies to be aided or administered too, or indeed for the proper gifts to be bestowed upon us, to empower us in such a way, that we can receive guidance and make affirmations

through the proper will and conduct of a satisfactory lesson learnt albeit through this practical application and understanding, if only to attain spiritual and fruitful lives.

As it is simply by recognizing that we are, or at some point or another in our lives, have always somewhat been open, or subject to the interpretations of spiritual warfare by reason of definition, in that Satan's interpretation of creation is something somewhat of contempt, in that God should do away with, or even destroy creation, but as much as Satan can only prove to tempt, or to provoke God into this reckoning, it is only simply by inadvertently influencing the concepts, or the ideologies of man, that of which whom God has also created to be creators, that man through his trials of life could also be deemed to be seen in Satan's view, that somehow God had failed in this act of creation, and that Satan who is also just an Angel, could somehow convince God of ending creation, as Satan himself cannot, nor does not possess the power to stop or to end creation, which of course is only in the hands of the creator.

And so this brings me back to the Angels, and of those that are in favor of either serving, or saving mankind from his own end and destruction, albeit that we are caught up in a primordial spiritual fight, that we are all engaged in, or by reason of definition born into, and so it is only by our choices that we ultimately pay for our sacrifice, or believe in our rights to life, inasmuch that we are all lifted up to our greatest effort or design, if we can learn to demonstrate and to accept our humanity in a way that regards and reflects our greater desire or need, to be something more than what we choose to believe is only in the hands of God the creator or indeed a spirit in the sky.

It was very much my intention not to state the name of any
particular place in the script as I thought that the telling of the story
of the Angel Babies is in itself about believing in who you are, and
also about facing up to your fears. The Angel Babies is also set
loosely in accordance with the foretelling of the Bibles Revelations,
as I thought it would be best to take this approach, as the writing
of the script is also about the Who, What, Where, When, How and
Why scenario that we all often deal with in our ongoing existence.
As it would also not be fair to me, or anyone who has read the
Angel Babies, to not acknowledge this line of questioning, for
instance, who are we? And what are we doing here? And where
did we come from? And when will our true purpose be known?
And How do we fulfil our true potential to ourselves and others,
as the point that I am also making in the Angel Babies and about
Angels in particular, is that if we reach far into our minds, we still
wonder where did the Angels come from and what is their place in
this world. As I know sometimes that we all wish and pray for the
miracle of life to reveal itself to us, but the answer to this mystery
truly lives within and around us, as my only hope is that you have
found the Angel Babies an interesting and exciting story as I have
had in bringing it to life, after all there could be an Angel Baby
being born right now.

Time is neither here or there, it is a time in between time as it is the beginning and yet the end of time. This is a story of the Alpha and the Omega, the first and the last and yet as we enter into this revelation, we begin to witness the birth of the Angel Babies a time of heavenly conception when dying Angels gave birth to Angelic children who were born to represent the order of the new world. The names of these Angel Babies remained unknown but they carried the Seal of their fathers written on their foreheads, and in all it totalled one hundred and forty four thousand Angels and this is the story of one of them.

As the Sun stretched forth its' rays, sending beams of light far and wide into the land of oblivion, Papiosa feared that he would be burned and consumed alive by the eternal fire and flames of the everlasting and infinite golden dawn, but in being so brave and forthright, steadfast and determined to fulfill his obligation in all that Angelo had set upon his heart and minds imagination, there he sat watching the rising sun with the presence of Angel Leoine beside him.

Angel Leoine

Now that you have witnessed the golden dawn Papiosa, tell me how did you come to learn of this?

And so Papiosa began to tell Angel Leoine his story of trial and tribulation from the time of its' inception, beginning with his dreams as a young boy by his mother's side, until the famine had taken hold in which many people of his village did not survive, at which point Papiosa with much guilt and despair, revealed that maybe in his being born was the true reason why the famine came, and that he were somehow responsible for this bad omen which left so few fighting for survival, inasmuch that the people reflected it in this by turning their backs on him, as if he were nothing more than an accursed madman in their midst, whom no could allow or come to know.

Papiosa also spoke of his own personal fight for survival, living off wild berries and shrubs, whilst exploring the vastness around him, praying each time day by day by the only remaining stream in the village trying to catch and yield any fish, believing that somehow his prayers had been answered and with each fish he caught, that somehow a soul if not his own had been saved.

At this point Angel Leoine had become happy and aroused.

Angel Leoine

Tell me Papiosa, do you not find it strange, if not peculiar that you amongst many should escape your fate and not perish by the famine, or that by a simple prayer, you should find a little comfort and food for thought by the only remaining stream in your village, but tell me more, I want to know everything in your heart and your minds imagination, tell me, what do you know and what you can remember.

And so Papiosa sat and reflected for a while, and then he began by revealing to Angel Leoine his first encounter with the one he came to call Angelo, and how every night he was tormented every night whenever Angelo came to call, and how every night in his dreams he would die before being called forth into his own resurrection and awakening, and every night dying, and every morning living, until that fateful moment of his vision and his ascension into the realm he came to know as empyrean.

And now that Angel Leoine had learnt of his trials and tribulations and the coming forth of the one she had anticipated and come to know as Papiosa, she began by explaining how all things were meant to be, in saying to Papiosa.

Angel Leoine

When you dreamt, you stood in the doorway of Eden, this was the beginning of your journey and then when you thought you had died, you did not, but you were taken up into the several worlds, and then in this world you were given a gift, and if put to good use would become the key to your freedom and salvation, but tell me Papiosa, if it were possible to turn back the hands of time, and for you to become reconciled with your mortal soul, tell me what would you choose to do?

At this point Papiosa became confused.

Papiosa

But is this possible, how can it be, when I Papiosa am here with you in the presence of the Bastion.

Angel Leoine

Anything is possible Papiosa, do you not remember that it was your spirit and not your mortal body which was taken up into the several worlds, if you dream deep enough, you shall see that you are still asleep, where the one called Angelo left you.

Papiosa

Where, where do I sleep?

Angel Leoine

There on the ground at the foot of the four sided valley, protected by me.

Papiosa

But we are in oblivion, are we not?

Angel Leoine

Oblivion is no more, you witnessed that it is swept aside and cast out with your own eyes, did you not?

Papiosa

Yes I did

Angel Leoine

So now tell me, if you could go home right now, would you choose for me to awaken you in the Tetra Valley

For a moment Papiosa became still and peaceful and then he looked toward the Bastion Leoine and said.

Papiosa

No! I have had enough of dying and living in one almighty breath, and I have no need to see the things of places I wish to forget

Suddenly Angel Leoine became agitated and angry, and instantly flew to her feet in fury.

Angel Leoine

What do you mean forget! Then what else is there, if not for the past, there is no future, what did you expect, that you could sow and reap nothing

Then Papiosa in his own affliction and aggression shouted.

Papiosa

There is nothing!

Angel Leoine

Then I should kill you now! To show you that killing goes on forever, don't you see that this is all there is, only nothing can beget nothing, and therefore nothing can exist, and this is a fallacy to believe otherwise

Papiosa

But people come and go

Angel Leoine

Yes they do, all things must come to pass, but there is never nothing, can you not understand, we are what we are, an Angel and a mortal alike.

Papiosa

But you are an Angel and a sentient being, and I am a mere mortal man, of flesh and blood.

Angel Leoine

Do you not see Papiosa, that you have the advantage over me

Papiosa

But how?

Angel Leoine

Because you are blessed and you can die if you don't choose to live, but I am forever more, coming and going at your will and discretion, its' not fair that you should possess this power over I who have never loved nor known love, the way that you have.

Papiosa

But I don't understand, how can you envy me, when it is I that should envy you.

Angel Leoine

Nay Papiosa, it is not envy of which I speak, it is love.

And they both fell silent for a little while, until Angel Leoine spoke again.

Angel Leoine

You are a traitor

Papiosa

A traitor, why, why do you now accuse me for what I have not done?

Angel Leoine

You have betrayed humanity, if you believe in nothing, then your words are useless and mean nothing

Papiosa

No! My Bastion, do not condemn me, did I not urge Mercy to free the outcast and forgotten

Angel Leoine

You did, but you did it for nothing, you are their jailor, and now they shall become nothing, having no place to go

Papiosa

But how, why do you say this Bastion?

Angel Leoine

Because it is true, and because you do not possess the might and the imagination to guide them home.

Papiosa

But there is no hope and there is no home, there is only suffering and dying.

Angel Leoine

Then this shall be your legacy Papiosa

Papiosa

Then I have failed to find truth in resolve

Angel Leoine

Yes and I have failed to find triumph in love

Papiosa

What do you mean, an Angel cannot fail, can they, tell me Bastion is
this true?

Angel Leoine

It is true that I have failed you, inasmuch that I love you, and I desire
to live and die beside you if need be

Papiosa

But how can this be Bastion?

Angel Leoine

It can be if you desire it

Papiosa

But in a million breaths, if it were possible, then I would say yes

Angel Leoine

Then it is done, one day we shall eat fish together by the stream you spoke off and we shall save every mortal soul if not our own, come I want to show you something

Papiosa

What is it this time?

Angel Leoine

Have faith in me Papiosa, for I want to show you the Golden Dawn

Papiosa

But I thought . . .

Angel Leoine

You thought, but you did not see

And Angel Leoine plucked her bow and shot a flaming arrow into the overpowering Sun, and it was done, finally everything remaining in its path was swallowed up until there was nothing other than the shadow of heat across the plains, with the Sun now setting over the horizon, and there one by one, they all began to assemble in the Tetra Valley, where the sleeping body of Papiosa lay, and as the multitudes gathered, a voice could be heard in and amongst the gathering crowd, it was Angel Leoine.

Angel Leoine

Let me through, I want to be the first to wake him

And as Angel Leoine approached Papiosa's body lying on the ground, she outstretched her mortal hand to touch his resting body as she whispered into his ear.

Angel Leoine

Papiosa, wake up, it's me, Leoine

And as Papiosa had arisen, she greeted him with a warm and beautiful smile, there in front of him stood Leoine, along with the entire multitudes and the household of heaven.

Welcome

And so as the multitudes gathered there at the Tetra Valley, the skies above gave way and Angel Zyxven came forth carrying with him, an open book that had been given over and handed to him, for the sake of the Empyreans, and so as he removed the veil that covered his face, he began to sing a song that was so old, it seemed to echo throughout the open court, whilst entering into the ears of the congregation, drowning out all the thoughts in the minds of the people, and becoming infinitely louder and louder, whilst increasingly growing in volume and intensity with each new passing phrase of breadth and depth of conviction with which it was intended to carry its message of truth.

And there in the open court, everything and everyone became still, as the air fell silent round and about them, but that was just for a short moment in time, until a slight murmuring of sound began to stir up from the Angels and the onlookers of the open court, who had now surrounded and gathered on all sides, and such was their observational silence, which was by now to become broken, as they unanimously began chanting the name Zyxven, Zyxven, Zyxven over and over again, until his own voice spoke like a distant memory, as it rang out like a song that could be heard resounding thereabouts, revealing the forethought of intelligible knowledge throughout those that were present, even as a silent humming had begun through the translation of the congregation that had struck a primal chord and began resonating with influential sustenance, whilst touching and influencing each and every mortal soul that had became responsive to its vital and initial undertaking, although none who were presently there, truly knew, or were aware that a trial had begun to take place, now singing its' song of inheritance throughout the wind to these meek and humble souls.

Angel Zyxven

Never say never, and yet never is said, and yet never was there once nothing, and yet everything once was, and so too do we say, Thy will be done, and yet all remains undone, and so too do we say, So shall it be written and so shall it be done, and yet still the truth remains the same, as it once was, and now it is upon the singularity of our own being, in being instrumental upon the heads of the Trinity, and all held in the Eternity of their own occupation in the Seclusion of 111.

For it was the bright and morning star that was the first ordained, to bring about the world and its' peoples and all therein, to seek out, and to save the world from its burning and destruction, and away from its' ravaging tyranny and violence, if only to demonstrates and uphold its virtues in all the forms of its creation, for if it were not made to be possible for all therein to be set in accordance with he, that in all his merits, could be judged in accordance with that which he would and could protect, and watch over its' domain and the dominions therein, for no Man, Woman or Child could be brought into life without an account of it.

And so if he could not give witness and account of it, then to whom would such a task and responsibility become attributed to it, and so let all whom are present, and all who are free enough to live and to labour upon the Earth, but are still also held in contempt of it, bear witness to its age of enlightenment, as for those of us whom we are to explain in our examination of it, if not towards he, the bright and morning star, then towards none else except our Saviour in the highest high.

As when did he first appear from our primordial senses, to give us over to this wickedness in the event that we in the world would become corrupted enough to turn away from the very body of our making in creation, for had not the procession begun, during and after the heads of the Trinity and all held in the Eternity of their own occupation of the Seclusion of 111, was the Symbol drawn upon the mark of Man 666, giving rise to the Myriad and the many countless things that would come forth from Angel Satan the brightest and morning star.

And yet he of the highest esteem would be on the right side, and yet guide all else to their rightful place within the domain of the dominions unto destruction, but would seek to find no faith in its' sight, and yet still uphold the sanctity of Heaven and the Empyreans, as if Heaven and Earth, or Life and Creation could be separated, and so throughout the ages of time Mankind was forever being disconnected from the upper and higher echelons of the decrees and promises of a Heaven and rightful transition acquired through the definitive explanation and examination of him, that was its keeper.

And so as time had expired and proceeded forth, after one thousand four hundred and forty three years, did the Saviour of the world Adonai 777 come into our forgotten Liberty and Sanctuary to example to us the mythical teaching and proper conduct of our instrumental survival, in knowing and learning, and engaging in good practice to comprehend and amend our isolation and separation from the heads of the Trinity, and all that were held in the Eternity of their own occupation and away from the Seclusion of 111, which was their perfection.

As Angel Zyxven spoke out, the crowd became attuned and focussed as they fixed their gaze upon him, and the attentative sound of his voice as they listened intently to his words.

Angel Zyxven

And so it was to be, that in our comings and goings, that upon the aeons and the cycles, and the rotations of the Earth, that Life would predict Mankind's calamitous and disastrous history, every one thousand three hundred and thirty two years, much to our ignorance and misunderstanding of it, for if we were to realize that we were indeed separated from the creator, then whom could we rely upon, to bring us all back into reconciliation, with all that we had become disconnected from, if indeed we were able to recompense for such acts in the first place.

As even in our explanation and examination of the truth, we aim to be honest and obedient and forthright, and open and loving in our nature, insomuch so that it also easy for us to be deceived and led astray and contrary to it, and so who is at fault if we are not, and who is responsible enough, if we are not, and who are we if not these words that we speak and the actions that we display, and yet how can we turn away from it, when we do not yet know who to turn too, as such is the deception of the World and of those who do nothing to serve and protect it from such burning and destruction, and tyranny and violence.

For he that has said get thee behind me Satan, has no knowledge of this, except other than through his or her own merits of faith, as for the disciples of the bright and morning star, they have many guises upon with which to escape this inevitable fate, as we must all one day come face to face with the reckoning day and hour of our own destiny, and so for those of us who have also said to one to another, what will, or shall we pronounce to say to Adonai upon the day of judgement, that is to say, that even if we are to presented with an opportunity to come face to face before God's good grace, to give such an account of ourselves in such perilous and treacherous circumstances, in order to be deemed worthy and made wholly acceptable in his inextinguishable love for us.

Say nothing, for your hearts have already jumped forth from your mouths, and your ways have already been declared, and your decisions and destiny, and your words have already resounded within the Heavens, and your way is already laid straight before you, and for your sake, never say never, and yet never is said, and yet never was there once nothing, and yet everything once was, and so too do we say, Thy will be done, and yet all remains undone, and so too do we say, so shall it be written and so shall it be done, and yet still the truth remains the same, as it once was, and now the breadth and the depth, is upon the singularity of our own being, in being instrumental upon the heads of the Trinity and all held in the Eternity of their own occupation in the Seclusion of 111.

For he laid hold of the Dragon that Serpent of old, who is the Devil and Satan and bound him for a thousand years and cast him into the bottomless pit and shut up him and set a seal on him so that he should deceive the nations no more, from the pit of the Abyss came forth the Serpent of old Satan, as he arrived and made his presence known amongst the Saints and the Prophets and the entire household of Heaven, who were there to bear witness to the trial of the Dragon Devil Satan.

And they gathered them together to the place called in Hebrew Armageddon, who is a liar but he who denies that Jesus is Christ he is Antichrist who denies the Father the Son, for many deceivers have gone out into the world who do not confess Jesus Christ is coming in the flesh, this is a deceiver and an antichrist, they shall no more offer their sacrifices to demons after whom they have played the harlot, this shall be a statue forever for them throughout the generations, They sacrificed to demons not to God, to God's they did not know, to new God's new arrivals that your Father did not fear, if Satan cast our Satan he is divided against himself, how then will his Kingdom stand, lest Satan should take advantage of us, when we are not ignorant of his devices.

As Zyxven continued to speak, the people became restless and agitated, and somewhat mystified and even uncomfortable by his relentless prophesying.

Now when the thousand years have expired Satan will be released from his prison, but Saints and Prophets of the Jury, it is not Satan the Devil that is on trial this day of judgement, but God himself, as you will soon realise, was it not God who spoke a lie when he said in the Garden of Eden, that if Adam or indeed Eve should partake of the forbidden fruit of the tree in the furthest part of the Garden, that they would surely die, and die they did not, but inasmuch they became increased in knowledge, and were made aware of the truth, that their very being were indeed naked.

Might I also hasten to add that it was God's will that Satan should be allowed to tempt Job in every way possible to Man, to see if Job would renounce his faith and belief in the Kingdom of Heaven, if Job was such a faithful servant of the Lord, then none of these trials and tribulations need not of happened, but what we see here is God allowing Satan to be free as any other in his Kingdom, for instance Satan was free to tempt the Lord Jesus Christ for forty days and for

forty nights in the wilderness, Satan simply gave the Son of God a choice to choose, as we all have a choice in this life to make choices.

For what you will hear on this day in the age of enlightenment, is how in the very beginning of time when in all its glory, God did indeed create the Garden of Eden and placed inside it, a Man and a Woman, but despite all that which was promised to be the very least of God's creations, the accused appeared in his hideous form as a serpent to deceive the first born of God's creation to all Mankind, and what you will also bear witness too, is how the accused tempted the Lord Thy God, by forcing him to hand over to his Will, Job, an upright, blameless and faithful servant and all his possessions, so that he may indeed prove, as he did not, that Job would renounce his faith in God and the Kingdom of Heaven.

And what you shall also hear upon the age of enlightenment, is how this same Devil tempted the Lord Jesus Christ for forty days and for forty nights in the wilderness, as the Son of God endeavoured to begin his Ministry to bring us back into reconciliation with God, and so there you well and truly have it, I leave it up to you whether you find Satan guilty of all these things mentioned on this day of judgement, or if indeed God is to be apportioned the blame in this judgement, for the devil who deceived them was cast into the lake of fire and brimstone, where the beast and the false Prophet are, and they will be tormented day and night forever and ever.

As for the disciples of Satan, they would say anything to materialise their every wish, and so we in return must do everything in our power in exercising good judgement and foresight in expelling anything that is not of our inheritance, for how can we claim that which is not of our own creation or making and be partisan to it, for inasmuch, we did not make the World, but still we choose to live upon it for our own sakes and by the grace of God.

Angel Zyxven

And yet why does the voice of dissent arise out of the darkness's, with us to be found accusing one another through the persecutions of insinuations and accusations that would instantly set us apart, as if we in our ignorance knew any better, and where does this dissent arise from, if not from within our own hearts and minds, and why are we to be accursed and apportioned with excessive blame for no other reason, other than that with which we had been brought into being because of our Worldly inheritance.

And still the people remained somewhat discerned and troubled by the words of conviction now being expressed and spoken so forthrightly by Angel Zyxven.

Now when the next thousand years have expired between 1998-2331 Anno Domini, Satan will be released from his prison, but Saints and Prophets of the Jury, what we have said in our hearts, we have also spoken in Heaven, and yet what we have witnessed on Earth, has not met with our expectations, and so why should we be threatened by the reality of our own making and devices, and why should we seek to threaten each other because of our own ignorance and misunderstanding or misinterpretation of the scriptures, when we have also said anything in our hearts anything to watch it materialise it in our every wish.

And yet in saying everything, we have abandoned all hope in our reconciliation back to our Heavenly home, and yet what can we say in our defence of it to one another, in bringing us back from the brink of destruction, and into a place without contempt, for surely if we open our hearts, we shall receive our portion of these blessings from the highest high, and yet when we close our minds to the reality of our times, we simply give ourselves over to the corruptions of Satan.

As one by one we are all appointed with a gift of Life, and a blessing to cherish, and yet still we remain discontented and dissatisfied with all therein, and so once again with the spoils of gain, we are easily corrupted by the one who knows all too well, how easily it is for us to be led astray through contemptuous and mischievous acts, as there is no place for hate to reside alongside goodness, and yet we do not apportion nor attribute enough to God, as much as we should blame Satan for his meddlesome behaviour and interference endured through the disappointments in our lives, as we are surely abandoned by him, once we have proved our uselessness, in being an instrumental tool in provoking the disapproval of God.

And so which one shall decide who must live and who must die, if all glory is to the creator, and so the bright and morning star, cares not for you, but for himself in all authority over his domain and dominion, as too also is all worldly sorrow manifest, because we do not rejoice in the glory of God, in becoming triumphant, for we do not bear witness to that which we in our ignorance cannot yet furthermore comprehend in our own understanding.

And yet to remove the burden, is for the lie of deceit and deception to cease, and yet we, who are in the midst of darkness, believe that it is the light that we reap, as we cannot see beyond the shadows of our own darkness, that we have given ourselves over too, as is the eternal power struggle for Life and Death simply true, by simply saying or calling onto God or Satan, for there is no need of the burden of this lie to exist in God's Kingdom.

And yet further still as the people listened to Angel Zxyven, some became much more reassured and somewhat gladdened and enlivened in their spirit, of what would prevail and come to be in the eventful days ahead.

Angel Zyxven

And how be it that Satan could rob you of your senses, and plant the seeds of doubt and heresy into your minds, as to whom should be glorified in the Heavens above, and in the quest for life and eternal salvation, as it is so easy for one with the ability to poison the mind with the trickery of lies and deceit, that we in our tongues and ears would curse and blaspheme against God in the highest high, so let us not forget that it is only in our greatest glory that we are open and subject to such divisiveness, and so let us not conclude in accusing the household of Heaven in being in contempt of our own corrupted hearts, as such is the dividing line between truth and deception.

Insomuch that the truth is not addressing you personally, but is equally found to be communicating directly through you and to your spirit, so as to bypass any confounded conception that is contrary to what we believe and perceive as the laws pertaining to God and the Heavens above, which has already become corrupted just by merely contemplating any Satanic Luciferian and devilish philosophy, in its initiation of professing and bargaining with any statement in its concept, as such is the surgical instrument of the chief musician of Heaven, in whittling out the weeds from the Heavenly plants and flowers that were planted there within you as both a gift and a blessing, inasmuch that lest we forget to fear God, in remembering that this battle has already commenced and taken place inside of you, in knowing that God has already won the war, so how can we fear the trepidation and treacherous acts of a devilish concept.

For only the spirit knows the divine relationship and prophetic language of God and the Heavens pertaining above, for the primal forces of nature are already obedient to this Will, and were already witness to the almighty power of God in the highest high and the Heavens above, as the world did not see this event coming forth and unravelling, much to their surprise, until they opened their eyes to receive their Heavenly inheritance, which could so easily have been snatched away by one so cunning and deceitful, so as to influence us all to abandon hope, or indeed for us to somehow differentiate and conclude that a Kingdom had been lost.

For had not the forces of Heaven been given over to God in the highest high, nought else could sustain us in our time of need, inasmuch that Adonai 777 would be given over in his spirit to come and dwell over and amongst us, and walk in the ways of the world, so as to explain in his examination of us, the many ways in which we were to walk, and to amend, and to reconcile our ways back to our Heavenly home, which is and always has been the dwelling place of this his good counsel, and the heads of the Trinity, and all held in the Eternity of their own occupation in the Seclusion of 111, as such was the sacrifice, that we would come into union through him, as such was the cost of his precious life, that he would seek to take the might, and the weight of the world upon himself in the name and the saving grace of Jesus Christ.

And so the Father has given over the Son to the world, to save it from its burning and destruction, and away from its' ravaging tyranny and violence, if only to demonstrates and uphold its virtues in all the forms of its creation, and to lead it towards Salvation and Redemption, in the many ways that he explained and exampled, that we might be saved from our own death, and yet how do we respond and repay such an act, and how do we know and display in appreciation, if in all truth we have been saved, and how be it that we have acquired this spirit of knowing through this inclination

and examining of the scripture, and yet still we remain in the darkness's of our own making, or could it be that we are still mystified by Satan's Luciferian and devilish deception, to fool us in a false sense of belief and gratitude unwittingly, until the last day of our judgement has befallen upon us, so that we too are lost to the reconciliation of our forthcoming glory, and when it is too late to call upon the hosts of Heaven, to lift us up and out of our suffering and misery.

And yet further still, how is it that he who has nothing, bears the promise to give us all and everything through the sacrifice of his own Son, nay never say never, and yet never is said, and yet never was there once nothing, as everything once was, and so too do we say, Thy will be done, and yet all remains undone, and so too do we say, So shall it be written and so shall it be done, and yet still the truth remains the same, as it once was, and now it is upon the singularity of our own being, in being instrumental upon the heads of the Trinity and all held in the Eternity of their own occupation in the Seclusion of 111.

Suddenly Angel Leoine let out a screeching scream from the depths of her soul that echoed and spread like a Dolphin's cry, reaching both far and wide, until in an instant there appeared the Angel of Justice, and the Angel of Mercy once again brandishing a mighty sword in her hand.

Papiosa

Mercy! Justice!

Angel of Justice

You should speak when spoken too Papiosa

Angel of Mercy

What do you want Papiosa?

Papiosa

I want to see the Golden Dawn, once more

Angel Of Justice

For what reasons Papiosa?

Papiosa

So that we can be set free

The Angel of Mercy and the Angel of Justice Look puzzled, whilst noticing the presence of Angel Zyxven.

Angel Of Mercy

And who are you?

Angel Zyxven

I Am Zyxven

Angel Of Justice

And what Is Zyxven?

Angel Zyxven

I am from the sanctuary of Haven

Angel Of Mercy

A Sanctuary you say, and what sanctuary is this?

Angel Zyxven

The Empyreans!

The Angel of Mercy becomes somewhat cautious and suspicious.

Angel Of Mercy

What! Stop this at once

Angel Of Justice

No Mercy, it cannot

Angel Of Mercy

Then you know of the bright and morning star?

Angel Zyxven

Yes, I do

Angel Of Justice

Then we must pass judgment

Angel Zyxven

No! You may not

Angel Of Mercy

And why not?

Angel Zyxven

As all has become established and brought into accordance with itself through me

Angel Of Mercy

Then prove it!

Angel Of Justice

No Mercy, he cannot

Angel Of Mercy

Well maybe he could prove it, if I were to swing my blade in the name of Justice and Mercy, then heads shall roll if any of my demands and warrants are not adhered too, in this place you proclaim to call sanctuary

Angel Of Justice

No Justice, let me kiss him and see if he lives

Old Woman

Oh No! Not again

Angel Zyxven

I suggest that you desist from such action

Angel Of Mercy

Desist! Desist! And who are you too challenge the actions of Mercy

Angel Zyxven

Because it is forbidden, and I am Zyxven, the sanctuary of Haven

Angel Of Justice

Which Haven, I only know of the Haven of security or safety,
what kind of Haven are you?

Angel Zyxven

This Haven is also my Haven, a Haven of love and life and liberty

Angel Of Mercy

Then prove it!

Angel Zyxven

But if I kiss you Angel of Mercy, you might die

The Angel of Mercy laughs out loud to herself.

Angel Of Mercy

Die, A creation of the celestial abode die, but how can that be, when you are only half an Angel, a half breed of distinction

Angel Zyxven

Believe me Mercy it can be, because I am Zyxven

Angel Of Justice

And what is Zyxven compared to us?

Angel Zyxven

It is your judgment that I hold within me, compared to you

Angel Of Justice

But how can that be?

Angel Zyxven

Because it is so

For a moment all around fell silent, as the Angel of Mercy stared directly into Zyxven's eyes, almost knowing that he was so much more than he appeared to be.

Angel Of Mercy

Yes, Yes, you are aren't you, finally, finally God has surpassed himself and created something out of nothing, far more superior and even more advanced from me, is that even possible, well wonders will never cease to amaze, well I say Amen to you Zyxven of the sanctuary

Angel Zyxven

And I say Amen to you also Angel of Mercy

Just then all eyes turned towards Papiosa.

Angel Of Mercy

So Papiosa, you want to be free! But free from what, where there is judgment there is no freedom, and where there is freedom there is only sacrifice

Papiosa

No Mercy, free them with a gift from the heart, surely you remember your own heart beating inside your own bosom

Angel Leoine

Mercy it is true, he is right, let them seek out salvation through their own will and virtues

Just then, the multitudes gathered around Papiosa, as he exampled each of them by falling to his knees and coupled his hands, as he urged them all to pray, as even they all seemed troubled and confused and doubtful, and less and less willing to speak or utter any words of intent upon their redemption.

Old Woman

Why must we pray Papiosa?

Papiosa

We must pray to soften her heart, if she has one, we are praying for deliverance, we must pray for our childhood dreams, we must pray for love and for salvation, we must pray for freedom

And so one by one, each and every soul began to pray, as they had never prayed before, and as they're prayers began to soften Mercy's heart, eventually she lifted up her sword and wielded it above her head, and then suddenly swung it down striking the ground in front of her, and then the ground began to rumble and shake beneath them, and as it did the people became still and frightened by this spectacle, so much so, that it somehow caused their bewilderment to cause them to utter and speak in several separate languages, in that it had somehow filled them with a source of purity and light that began to fill their hearts, and to heal their souls from within, from their previous convictions and binding afflictions.

And so it was that when Angel Zyxven had concluded in delivering his prophetic message from the legacy of the Angels of the Empyreans, that the multitudes who had responsively heard and witnessed upon reaction to his words, had gathered themselves together, and were eventually convinced to go in search of their own everlasting Salvation, in the strength and the knowledge and the conviction that had been taught and prophesied by Angel Zyxven, and also in knowing full well that this message that had been delivered and granted and conveyed to them, had also presented them all with a purpose and an opportunity for going forward with a reason for living their precious lives, and to go out and seek to fulfill their precious dreams and ambitions, by pursuing the right accord through this inceptive and intelligible knowledge, that had been so enchantingly and eloquently imparted to them, and so it was that each and every one of them that had received this message, was to begin by departing from the Tetra Valley, and went out and beyond the new frontiers of a world becoming anew.

And in that moment the Angel of Mercy and the Angel of Justice were both gone, leaving Papiosa and Angel Leoine amongst the multitudes to gaze upon the horizon, and once again Angel Leoine took forth her bow and took aim and fired it directly into the sky, and as she did so, a magnificent Sun came arising upon the skies horizon, until there was nothing other than the shadow of a burning heat sweltering across the plains of the Tetra Valley.

Angel Leoine

Finally, it is done

Papiosa

But is it Bastion, is it?

Angel Leoine

What else did you expect to see Papiosa?

Papiosa

It is him, is it not him?

Angel Leoine

Who do you mean Papiosa?

Papiosa

The one who sits on the right, is it him or not?

Angel Leoine

Yes, it is him

Papiosa

The bright and morning star I mean

Angel Leoine

Say nothing Papiosa, for there are other worlds to consider

Papiosa

But how Bastion, how?

Angel Leoine

Because . . .

Papiosa

Because of what?

Angel Leoine

Because it is so, and nothing can stand outside the laws of creation

Papiosa looks towards the Sun with a curious element of suspicion.

Papiosa

But tell me Bastion, what does this Bow striking at the heart of the heavens signify?

Angel Leoine

It is the Bow of Nimrod piercing at the bosom of the Heavens that gives way and rise to a new day that is why it is so significant

Papiosa

But then how is it that a new day proceeds forth, when the same Sun presents itself to us Bastion?

Angel Leoine

Because it is us and not the Sun that is advancing towards a new day, the Bow is simply a sign of that new day dawning

Once again Papiosa looks towards the Sun, puzzled by its' constant and infinite glare.

Angel Leoine

Do not hold the Sun in contempt Papiosa, as you will find no answers there

For a moment Papiosa was silent looking very puzzled at Angel Leoine.

Papiosa

You know Bastion, after hearing the words of Zyxven in the Tetra Valley, for a moment there I thought that I knew everything that there was to know about this world, and for a second everything seem to make sense, but now I realize that without God, that all is detrimental and fatalistic and futile, I mean why would something so freely expressed and given, also be made to be used against us in our moment of need and of hope and glory, and how is it possible that they are one in the same and two sides of the same coin

Angel Leoine

Papiosa once we make up our minds and realize what we want in this life, suddenly the reason why it is so easy and yet so hard to obtain it, is simply because of the simplicity of our mind and nature as to whether it is any good or even right for us to pursue such objects in the first place, as everything is a test of our faith, as to whether we really appreciate these things that we claim to value and put above God, and if it is so, then it is this object that shall be used to sway our souls in the balance between God as to what is good, and between Satan as to what is not good for us, so as to lead us to our greater appreciation and understanding of what the value of life really holds,

Papiosa

So even though I possess the ability of my free will to choose, and to do as I would like to please, then what you mean to explain to me, is that my choices were somehow preordained, whether I thought I was free of such independent and divine laws or not

Angel Leoine

What Zyxven simply meant to say Papiosa, is that it is our choices
that will determine who or what shall become of us in our fortunes
of fate in this life, as these things that we all pursue are all but
temporary, whereas God wants to fulfill our lives with something
of value and permanence, whereas Satan would deceive us into
believing that it is not so, so as to use these things against us, and to
deny us our true inheritance, which above all stands with God

Papiosa

Then fly with me Bastion, fly with me over the sea in the love that
we sow, so that we are all indeed at liberty to begin anew

Angel Leoine

But how many more Golden Suns do you expect to see in your
lifetime Papiosa?

Papiosa

Well how many more are there Bastion?

Angel Leoine

There are many more

Papiosa

Then come, show me these other worlds

And so it was that Angel Leoine and Papiosa departed company from the multitudes in the Tetra Valley, and as the stars in the sky began to move in their gravitational orbit above the Earth, still Papiosa accompanied by Angel Leoine chose to dwell in the nothingness about him, within the midst between the Sun and the Moon, where the earth hands up all those who have lived and all those she has forgotten, and this is where we find him, watching all that which is born and all that which is given up to the lower, and the mid and the higher points of the last remaining three Heavens, but slowly a lonesome fear and hunger began to take root in Papiosa Heart, as he had become a Man without hope or faith.

Papiosa

But tell me my Bastion, how do things die, as I fear that I shall grow weary one day and perish

Angel Leoine

Things do not die Papiosa, they simply change and keep on changing

Papiosa

But why then do I fear death more than God?

Angel Leoine

You fear only the loss of mortal things that cannot sustain you Papiosa

Papiosa

Then who is God, surely I have a right to know this much?

Angel Leoine

God lives inside of us Papiosa, even you are God when you do not
see that you are

Papiosa

But how can that be, I did not create this world Bastion

Angel Leoine

No perhaps you did not, but you did help in bringing about its'
creation, as we all did, as you do not see the world how God sees it,
you only see it as Papiosa, as only I see you as Papiosa

Papiosa

But what of these other worlds Bastion, are they the same as this
one?

Angel Leoine

Yes they are all the same in a way, if they meet with our expectations
of them, then they are just as simple and as infinite as this one

Papiosa

And did God create them also?

Angel Leoine

Yes Papiosa, he created them also

Papiosa

Then who created God?

Suddenly Angel Leoine became upset and agitated

Angel Leoine

Questions, questions, questions Papiosa, too many questions, well I do not know, except that from out of the heavenly primordial forces he came, as God is in everything and everyone, and along with the elements and the seasons which are also partial to him, and so we do not see God as we know him, and we do not know him how we would like to see him until faith shows us the way

Papiosa

Do not lose patience with me Bastion, but where is faith?

Angel Leoine

Faith! Faith! Faith, faith is one of the highest Angelic virtues I have ever met, she is like the wind and only appears when the time is right, and she only presents herself to those whom she chooses

Papiosa

Then will faith take me to God?

Angel Leoine begins to laugh at Papiosa's naivety.

Angel Leoine

Well perhaps faith will take us all to God Papiosa

Papiosa

Well then that is good, I am happy to learn of this faith, I hope that she will appear to us one day soon

Just then tears began to fall from Papiosa's eyes, as too did Angel Leoine also begin to cry, as joy began to fill their hearts not so much with sadness but with a renewed happiness, and so too did a brisk chill come about in the air which surrounded them both, as they were unaware that it had also began to snow, but for how long neither of them knew, or how long the snow would take to reach the lower depths before it would finally come to rest and crystallize upon the frozen ground below, but no sooner than it did, and so it was that within that moment, that the Angel of Faith did indeed come to appear there amongst them.

Angel Leoine

Faith! From where did you come?

Angel Of Faith

Faith from where did you come, is that how you greet you bigger sister Leoine, did you not see me, of course you both seem rather frightened and surprised to see me, and you look, so lonely and cold by my being here, afterall did you not call out after me?

Angel Leoine

Yes we did, but we weren't expecting such a surprising visit

Angel Of Faith

Oh' you weren't were you, well silly me, sorry for making such a surprising attendance, am I missing something important, as next time, that's if there is a next time, in future I shall try to let you know when best to expect me,

Angel Leoine

Oh' Faith, I please didn't mean to upset you

Angel Of Faith

Oh! You didn't did you, so that makes everything alright now does it, well maybe I should just go and leave you to it then

Papiosa

No Faith please, do not depart

Angel Of Faith

Oh' now you remember me Papiosa, well that's a fine thing isn't it, funny how everyone forgets Faith when they're quite happy being beside themselves, until everything goes drastically wrong, and then they begin by begging, Oh no! Oh please, pleading for Faith to return, Oh' well here I am, now speak up and tell me what is it this time?

Angel Leoine

Be kind to him Faith

Angel Of Faith

Oh' Why do you weep so Papiosa, it is not in happiness that I have attended and appeared to come forth before you with, now come pray tell me what's despairs such a saddened soul, or are you somewhat disappointed and downhearted upon your discovery and revelation of me?

Papiosa

Do not taunt and tease me so Angel, I am weak with confusion, and yes I am at a loss in your presence upon my discovery of you, so please forgive me

Angel Of Faith

So where is your hope now Papiosa, or have you abandoned that also?

Papiosa

There is no hope without faith Angel

Angel Of Faith

There is no hope without Faith, sounds just like music to my ears, yes, it's true, there is no hope without me, and so you are forgotten in your faithlessness of me are you not Papiosa?

Papiosa

Oh' please Angel, do not spoil and mock me, show me rectitude and pardon upon your responses toward me, I beg thee rid me of my haunting torment and unspeakable shame and ignorance besides myself

Angel Of Faith

Hallelujah' at last he sings of his own sorrow and detriment, at last I shall do much more than that Papiosa, I shall reanimate you with your faults and defects attached, and then I shall send you back to the cradle of life that bore ye, and then I shall set about re-enacting you with your past until you have found your hope in faith and me once again,

Angel Leoine

Please Sister, be kind to him

Angel Of Faith

Please Sister be kind to him, Be kind!, how am I not kind Leoine, now let me see, ah' yes faith for the faithless, the lost and the found, through the narrow minded forgetfulness and zealot nature of seeking God in the name of thy profane and annoying self vanity of worthless satisfaction, yes it would seem unkind to blind you with this faith Papiosa, so I shall lament and concede a little upon the intercessions of my little Sister, as it would seem that you have lost your faith in seeking God which is not completely condemnable by my words alone, wouldn't you agree

Papiosa

Yes, yes I am guilty Angel, but please do not harm me, please I urge thee, let me plea with you for the bargaining sake of my own sanity

Angel Of Faith

Sanity! It's not sanity that I come to reckon you with Papiosa, it is
your soul, have I made myself clear, now perhaps you can tell me
exactly what you recollect and recount upon this questful journey
of your own futile making, and don't say in the beginning as it
infuriates me, and I may end up throttling you there where you stand,
and then leave you to defend for yourself in a state of limbo, and then
sadly I'll depart and disappear in a puff of smoke and leave you to
defend for yourself once again, in doubt and in ignorance happily.

Papiosa

But I don't recall anything Angel

Angel Of Faith

Well, well what about you my little Sister, how is it that you find
yourself in such a state of bliss with this poor creature that has not a
word of account with which to exemplify himself with?

Angel Leoine

I am his appointed one, but do not judge us Faith

Angel Of Faith

Appointed, by whom, Mercy or Justice, and by which decree, afterall
he is only a Man, and as far as I can see you do not yet possess a
girdled womb with which to carry him in do you

Angel Leoine

Do not mock us Faith, for we have already toiled and trialled with much to contend and endure with

Angel Of Faith

There is no need Leoine, this is already a joke, and I see that your heart is already smitten and I also see before me, that he desires to die before God does he not, or perhaps he only seeks to accuse the one upon the sacrilegious cross that bore he, or perhaps his cup is so full it runneth over

Angel Leoine

I don't know my Sister, except that he is inquisitive and wholly holy

Angel Of Faith

Oh but aren't we all dear, aren't we all, but no this is no wholly acceptable matter, this thing, this wretched thing without mercy and justice behind him, is no one thing, I urge thee let him speak and recall his mind to me

Angel Of Faith

Do you remember the other place Papiosa?

Papiosa

What other place, there is no other place there is only the here and now

Angel Of Faith

No Papiosa, the other place, do you not remember it?

Papiosa

What do you mean the other place?

Angel Of Faith

Oh ye' of little faith, the other place is what you want and expect it to be in spite of our individual efforts to remain independent, the other place can only come into effect through universal collective consciousness, upon the lateral lines where we all sub-consciously agree, the other place is considered an improvement upon a modern and more majestic place, the other place is evidently now but not now evidently sown, now do you remember it or not?

The Angel of Faith begins to walk around Papiosa, prodding at him at will, as she questions him about his shortcomings.

Papiosa

No I do not remember this place, or any other place besides it

Angel Of Faith

The other place is what fiction is to reality and what reality is to experience, and what experience is to knowledge and what knowledge is to truth, as truth is tantamount as being proportionate and of paramount importance and in accordance to this and other place

Papiosa

This place, that place, what place is there to speak of, I have
only ever felt death overshadow me, and I have only ever felt life
empower me, and I have only felt love lifting me, and I have only
felt time question me, and I have only felt truth examine me and yet
nothing remained in me, even as the child inside me was no more,
but the unwritten laws, and the unwritten laws,

Papiosa pauses to think.

Angel Of Faith

Yes Papiosa now go on, this is rather good, now tell me the
unwritten laws are what?

**Papiosa starts rambling to himself as he begins to recalls, things
that have happened to him before.**

Papiosa

The unwritten laws are statues that are performed, and stand outside
the natural laws of creation, how is it even possible, if they remain
hidden or unwritten, outside the laws of creation, everything is
possible within the laws of creation, therefore if the unwritten laws
can be achieved or made acceptable in thy sight, by either faith or
through prayer, or with healing through the purity of the heart, and
pure mind of good intent, then these acts can be witnessed on account
but need not be written in order to be granted, but can only be made
possible by the means of a miracle, he said the miracle being the
unwritten law, if achieved or granted, cannot be recorded inside the
natural laws of creation, and so therefore the fabric or the mettle
of this miracle, cannot be made proven or verified without divine
intervention or any other miraculous event in whatever form or shape

it could take, it was the seventh high, and yet I turned away and did not know it, is this the other place that you speak of faithful one?

The Angel of Faith becomes aroused and intrigued.

Angel Of Faith

Who spoke these words to you?

Papiosa

Wait! Wait, no wait a moment Papiosa remembers,

Papiosa begins to laugh to himself.

Angel Of Faith

What Papiosa, what do you remember?

Papiosa

It was he, the immortal one, he showed me a sign, and he said in the abode of the heavens that it was he who prophesied that it was he who should be the keeper of the seal of the unwritten laws and serves as a witness of the probable outcome and determinate fate of mankind and humanity between the heavens and the earth and all the realms and dominions in the life thereafter, I remember people began flooding off the Trains, Airplanes and Ships and began to gather in the one place, some in bewilderment and amazement at the glorious sight that they had now come to set their eyes upon, not one of them knowing who, what, where, how why or if they are arisen or what has befallen them to deliver them to this heavenly majestic place, those who left the Airplanes have yet to realize that this is a turning point an alighting point, and that this landing strip was unlike any other, and those who

had alighted from the Trains could clearly see not only the infinite running of rail track for miles and miles, but other vessels such as Ships, and those who departed from the Ships arriving into the port, dropping anchor whilst docking, realized that this is no ordinary port but the greatest sight to behold since the eighth wonder of the world, the shimmering, blues, turquoise waters glistening around them like a paradise untouched by human hand, all the Airplane Pilots, Train Drivers and Ships Captains were taken by surprise, for it were not their job or their duty, as seemingly authoritarians to give counsel and commands to the multitudes, who were now heading toward the light which shone in the distant horizon, a mysterious sky was now alight with brilliant and bright colors as if the sky were on fire, clouds dissolving and reforming at an instant, as the people who now stood shoulder to shoulder as they begun to receive divine messages from the chosen ones

Angel Of Faith

What was his sign Papiosa?

Papiosa

His sign, It was the sign of Pablo Establo Estebhan Augustus Diablo, hallowed be thy name, it was the sign of the seventh high pertaining to the three heavens, and I chose to ignore it, but what have I done, what have I done to me and my Mercy, oh please tell me oh faithful one, what is to become of me in my Justice for I fear the worst?

Just then A light shone in the distant horizon, and a mysterious sky was now ablaze and alight with brilliant bright colors as if it were on fire, clouds were dissolving and reforming at an instant, as if it had become one body that one would or could come to terms to associate with the body of Christ, as something began to stir upon the horizon, and bright shimmering lights appeared

in the distance, and clouds began seemingly to roll back and forth over themselves in eruptions of formations, seemingly to appear and disappear and reappear at will, as if something were erupting whilst moving through space and time and beyond, as also did the skies also began to darken upon the event of this new horizon, while the bright lights began to become even more and more brighter within the distance, as Papiosa was by now very much in subjection and very much unaware that his destiny was nearly complete.

And then from out of the great mass came three bright lights, which appeared above them descending from the skies above, dancing in the air like fireflies, flickering like star lights above their heads, until out of an event horizon a shadowy embodiment of a ghostly figure came forth glowing all about surrounding them, as it was plain now for them all to see that it was Angel Stefan, visibly upon the astral plains pointing them towards the direction that they must now take.

Angel Stefan

Seek no more to find us in other worlds Papiosa, as even I am here attentative to you, as also my son was attentative to me, who did also see through to me, as did I also see through to you Papiosa, even as the embers of hell fell all about me, even now as I am prevailing only to the justices of the light that shines within

And then in that moment he was gone, vanishing into the vast distant realms of the stars within, which gave way to an instant transformation of Papiosa's soul and re-birth of his former self, and once again the Angels of the Empyreans and that of the Celestial Abode beyond, were made to ascend toward their Heavenly home, as the age of Enlightenment was fulfilled, but the Bastion Angel Leoine who had still nurtured and felt a deep

need and obligation to be beside and to attend to Papiosa also ventured forward to go towards the unknown fate of her fortune.

Angel Of Faith

No Leoine, not you

Angel Leoine

But I want to go with him

Angel Of Faith

But if you go with him, you shall become as a human, and you shall live like a human, and you shall suffer like a human, and you shall in all inevitability die like a human, but above all else you shall not remember what it was like to be an Angel, is this what you want my Sister?

Angel Leoine

Yes, this is more than what I want, and I trust in the lord that you shall keep diligence and keep vigil, and watch over me from time to time

Angel Of Faith

And that I shall little one, but you must pray for me also

Angel Leoine

I shall always pray for you faith

Angel Of Faith

Well it seems that you love this one, more than you would admit and contend to love yourself

Angel Leoine

Yes, but only because it is easier to love him, more than it is possible for me to be loved by that which I fear the most

Angel Of Faith

But just remember my celestial Sister, it is only by the grace of that which you fear the most, that it is even possible for you to love at all

And so it was that Angel Leoine, who also followed into the realms of the unknown after Papiosa, not truly knowing that her fate of transformation was also to take effect, as the Angel of Faith, made the gesture of bearing the faith of whispered silences, by bringing her index finger to her lips, in knowing that Leoine would never again speak anymore of the Celestial Heavenly abode of that which bore her, but to where does this dream of the Angel Babies begin and how does it start, if there are no doubts in my mind then it always starts here, with me. As I am the point of reference for the time being, if this moment is the beginning of every awakening moment, as there is only this, the lingering and transient motion in space and time, and everything and everyone is relative to this, as I am to me and I am beside myself.

There are only two kinds of fallen Angels, as there are obviously those that have fallen from service and grace out of favour with God's decree and commandments of their loyalty and will to his Kingdom, and even though God does not completely abandon them, as they are at all time allowed and permitted to find a way so as to make amends if they so do wish and choose to seek forgiveness and be repatriated, and called once again into the service of his Kingdom, as it is much easier and simpler to judge accordingly such subordinate acts of Angels.

But when an Angel has quite simply fallen not from grace, but quite simply in love with those of whom they have integrally and selectively been assigned and chosen to watch over and protect, then it is not so easy so as to command such an Angel, or to judge in accordance with what such Godly decree has to be set down before them, as to what the best course of action should be to take, as such fallen Angels may still be considered worthy, or indeed held firmly in God's sight, as quite simply sincere, much because of their act of love over virtue, which may still be considered to be quite noble and virtuous in yielding their propriety toward such merits for admiring the human instinct and quality of human nature that has afforded them.

It is night time and the stars are shining brightly over a shanty town somewhere in a remote village in Africa, over previous years the land has been subject to famine, and by now only yields very little crop for food to eat, and these shanty town dwellers are to weary to go in search of greener pastures in order to aid their survival or indeed prolong their imminent suffering and inevitable death, there are only but a few watering holes to drink and wash in, and yet still only fewer plants and trees that have edible fruit fit to eat for human consumption.

But it is within this scattered community of broken souls, that Papiosa who is looked upon as a wise man and a storyteller, who is also accompanied by his pregnant Wife Leoine, who often listens but is always knowingly silent within her presence and movements, whilst Papiosa who on the other hand, is often seen talking with an excitable nature and an expression of passionate wisdom, somewhat baffling and dazing his mesmerised audience and onlookers, who often choose to sit themselves down besides his feet, as he openly engages them all gathering around, as he speaks to them about the Angels.

Papiosa

They say that the Angels dwell and reside just beyond the mid points
of the firmament, and the unseen world between the Heavens and
the Earth, and they say that there are Legends there, written off
and spoken off across the ages of time, and many are called but few
are chosen, and whilst my life is full and complete, there is little I
have achieved or even cared to have challenged, as I do not claim to
possess the key that could set mankind free or even set my life on a
true course to fulfill my own or anyone else's destiny, but once upon
a time

AUTHORS NOTES

The Angel Babies Story for me, was very much written and inspired by many feelings of expression, that was buried very deeply inside of me, as it was through my own exchanges, and relationships, and journeying, and upon the discovery of both negative and positive experiences, that often challenged my own beliefs, and personal expectations of what I thought or felt was my own life's purpose, and reason for being and doing, and very much what any one of us would expect to be the result, or the outcome of their own personal life choices based upon the status quo of our own design or choosing.

The story within itself, very much maintains its own conception of intercession from one person to another, as we can only contain the comprehension of the things that we most relate too, and that which most commonly resembles and reflect our own emotions and experiences, by tying in with something tangible that either connects, or resonate at will deeply within us, as many of us have the ability and intuit nature, to grasp things not merely as they are presented to us, but how things can also unfold and manifest in us, that are sometimes far beyond our everyday imaginings, and that are also equally hard to grasp and somewhat difficult to comprehend and let alone explain.

As we often learn to see such challenges and difficulties as these, especially in young minds, that react in responsive ways and are also equally gifted, or equally find it in themselves in life changing circumstances, to deal with prevailing situations, that most of us would take for granted, and would naturally see as the average norm, as we are all somewhat uniquely adjusted to deal with the same prevailing situation very differently, or even more so to uniquely perceive it in very different ways.

As for the question of how we all independently learn to communicate through these various means of creative, or artistic, or spiritual measures, is also simply a way of communicating to God as in prayer, as well as with one another, as all aspects are one of the same creation, as to whether such forms of expression can personify, or act as an intermediate medium, or channel to God, or indeed from one person to another, is again very much dependent upon the nature of its composition and expression, and the root from which it extends, and so for us to believe that our forebearers, or indeed our ancestors have the ability to intercede for us in such spiritual terms upon this our journey through life, is very much to say, that it is through their life's experiences, that we have become equipped, and given a wealth, and a portion of their life's history, with which for us to make our own individual efforts and choices, for us to be sure and certain of the way, in which we shall eventually come to be.

When we take a leap of faith, it is often into the unknown, and it is often associated with, or stems from the result of our constant fate being applied and presented to us in the context of a fear or phobia, insomuch so, that we must somehow, or at least come face to face with, or deal with, or come to terms with these matters arising, that are usually our own personal concerns, or worries, or anxieties toward a balanced or foreseeable reality, which is often beyond our immediate control, in that we are attempting to define and deal with this systematic physical, and spiritual progression, in the hope and the faith that we can resolve these personal matters, so as to allow us to put the mind and the heart at ease and to rest.

As it is often through our rationalizing, and our affirmation, and our professing or living with our beliefs, that what we often call, or come to terms with through our acceptance, is that through faith, belief and worship in God, that such personal matters, can easily be addressed, and dealt with, so as to overcome when facing such difficult and challenging obstacles, as even when in response to a negative impact that can have a harmful effect upon our physical bodies and being, we also often rely upon this same faith in the physical terms of our living and well being to guide us, and especially where we are often engaged in rationalizing with this phenomena, in the context of our faith, hope and belief, which often requires and demands us to look upon the world in a completely different way, so that we can reach far beyond the rational expectations of our own reality, and perceive to look forward into that of our metaphysical world.

As it is through this metaphysical world of all irrationality, and chaos and confusion, that a leap of faith is required to pass through and beyond the unknown context of our rational and conscious reality, and thus so as far as we can see, to understand our consciousness, as we believe it should be, in that we are contained in every aspect of our faith, hope and belief, as we are often presented with more than just a rational imagination, of what lies beyond our eventful fate or worries and concerns, and so within the mind of dreams, we are presented with a super imagination, where extraordinary things exist and take effect much beyond our physical comprehension, although very much aligned to the interconnectedness within our emotions, that brings with it a super reality, where we can accept the tangibility of these dreams upon realizing them, so as to be found and understood, as when we are found to be waking up in our day to day reality and activity, but also in choosing not to deny or extinguish these dreams as mere dreams, but to accept, and to see them, or refer to them as signs.

As of when we see such tell tale signs, or such premonitions forgoing, or foreboding us in our fate, it is very much that these signs often impact the most upon that of our conscious minds, as they are very much presented to us in an informative and abstract way, very much like a picture puzzle that we are busily attempting to piece together and work out, and very much in the way that we are attempting to put the heart and the mind at ease and to rest, so as to secure peace of mind in order to find and establish and maintain inner peace, as such signs as these, are often the ones that I am referring too, and can often and easily be presented to us in many ways, but to be sure and certain, if they are Godly or Diving messages upon intuition and translation, very much depends and largely relies upon us as individuals, as to what we are naturally engaged in and pursuing, in the same hope and light of the context, of this experience of such a Godly nature.

As such experiences are crucial and key, as to how we deal with any or all relationships, especially when we are developing a relationship within the Godly aspects of our lives, as more often than not, when we use such phrases and metaphors as, 'Going through a Door' or 'Crossing a Bridge, it is simply by saying such statements as these, or putting things in this way or context, that we decidedly know and acknowledge that a big change is about to occur, and develop or happen to us, and so we in ourselves are becoming equipped and prepared to deal with such changes, as they shall determine what shall be the eventual outcome of our fate, as there may already have been so many foretelling signs, much before the final impact or infinite sign is presented to us, insomuch so, that it may have already been subtly presented to us, much before the true perspective or picture of our reality has come to fruition and presented to us as a whole.

The whole being, is that which pieces itself together, with all the necessary facets and aspects of our Human Nature, Personality,

Mannerisms and Characteristics and Traits, as all in all, it presents to us a vision, which sets us apart from one another, but also equally ties us all together in the event and act of completing our picture and journey through life, and it is through these instincts that we all naturally possess, and is all that is inextricably woven into the metaphysical fabric and the spiritual aspects of the heart and mind, and of those that are channeled along the lines of the minds meridians, and the intricate channels that give way to apprehensible intuitive mental awareness of signs and dreams, and or premonitions or visions, of how, or what we may choose to accept, or to objectively analyze, or to take note of and perceive in communication, or indeed how God may choose to communicate with or through us.

As it is in our realizing that within our personal fate and decisiveness, that we are calling upon, and facing a reality, that questions and presents itself to us all, as something that is profoundly spiritual and ambiguous, in relation to what we are all intrinsically held and bound by within our faith and beliefs, in that what we expect is about to unravel itself before us, as we begin to discover all that in which we are, as such is the expectation and the realization in our phobias and fears, that we may begin to readdress or even regress, or desist in such a course of action concerning these doubts and deliberations, so as not to offset or to promote any ideas that may bring about any personal demise, or disharmony, or disunity, that may trigger any negative aspectual forecasts or emotions within ourselves, as it is such a self fulfilling reality, that we are all in subjection too, in creating along and upon our own individual paths of merits and natural progression, that naturally such phenomena is presented and revealed to us as a whole, and is often profoundly real and yet maintains its simplicity, and is quite ordinarily so upon our realization of it, as if by mere chance that somehow deep down we already knew, that when we became aware of it, we somehow knew it to be so.

As it is these lessons in life, that are to be learnt from such self affirming challenges, so as to test our minds imagination and of course that which is at the very heart, of how we in our Human nature, can so easily push our abilities far beyond the boundaries, upon the premise of what is, or what is not possible, which brings to mind the verse and saying of the scripture and that is to say, that if anyone adds or takes away from this book, then so too shall their part be added or taken away, and yet if we continue further along this point, it also goes on to ask, who is worthy to remove this seal, so as to reveal the dream or the foreknowledge that we may all come to terms with our natural agreement and acceptance of it, as it is in knowing and accepting what shall befall us in our fate, as to what choice of action we must or can take, as such are the phobias and fears of trepidation that also gives way to the rise of hope, so that we may come face to face with destiny.

As with each new day comes a new beginning, and with each new beginning comes new hopes and new expectations, as there are also new obstacles and challenges to overcome, as such is the dawning of life, to present to us all, such necessary and redeemable qualities within the observations of our lives, for to have hope, is to look up toward the heavens, and to quietly and silently know, that within this observation, that the sky or indeed the heavens, are still upheld by the forces of nature, that govern from above albeit much to our amazement and expectations, and that life is ordinarily and justly so, as we in our appreciation cannot always see beyond that which is so perfectly bound and set in motion with us in this universe, as we simply learn to believe and accept that this is the way of our living and all things besides us, as we are within all that has become created and laid out before us.

And yet with this new day dawning, if not for us to simply wake up and to use our hopes, and our aspirations to ascend beyond the obvious point of creation, and to apply our spiritual nature

and positive will of motivation toward it, and it toward us upon reflection, as in our overcoming and prevailing, within its and our own destiny and deliverance, as such is also our descent to take warmth and courage, and comfort and refuge, when we lay down to take rest and sleep beneath the Moon and the Stars above, is also to take strength and peace of mind, in the hope and the understanding that a new day beginning, and a new dawning shall be presented to us once again, as this is the way of the life that we have come to know it, within our own divine ability and acceptance of it.

As much as life is and can very much be a challenge, it also appears to state, that there is a thread of universal commonality running through the whole of creation no matter what we profess to live and abide by as human beings, as for me the basis of these requirements that extend from this commonality is water, food, shelter, clothing, companionship, well being, and a sense of connection or clarity derived from self awareness, that is not to say that there is not much more for broad scope beyond this basic measure and requirement that puts us all on an equal footing with one another, no matter where we inhabit or dwell in the world.

And so what and where are we permitted upon this universal basis, to gravitate towards, or indeed to excel to, in order to fulfill our existential experiences and engage with our full potential, as many of us in our progression towards modernity, would indeed interpret this kind of idea or philosophy, depending upon which part of the world we lived in or inhabited, as being very much viewed differently realized upon that same broad basis, which also brings me to ask, and to question, and to examine this brave new world within this context, or indeed as some would profess to say or mention, within this new world order, or new world system, as there is much to address and to consider for all concerned.

For once we have evolved and grown and matured away from our basic needs and requirements, it would also appear that many of us who have indeed excelled, or concluded in the context of a post-modernistic era of environment or society, to have almost achieved something, which is of a value, or at least on a par with something that is equally attributed, to that of a spiritual level of attainment, or indeed enlightenment, but when we address the cost of such achievement, we also begin to see that we are still somewhat grounded in our best efforts by this basic requirement, which is to achieve, acquire, and survive at will, and to endure, and to live, and to abide by such new discoveries of achievements.

As even in this progress and achievement of what we would wish, or presume to call a new world, how do we fairly address or balance, or differentiate between those of us who are yet to grasp the basis of this understanding that is required for us to excel, or indeed for us to fly, or indeed to reach the highest spiritual level of attainment of understanding, of being, doing, and knowing, as in realizing that indeed not many of us could have, or would have had the opportunity, or indeed the privilege, of exercising such expressions of freedom in our new found world.

As some of us are fundamentally held by the very conventions of what is required upon this, a basic level of our independence, maintenance, and survival, to regulate and maintain the simplicity of ourselves, and yet once we have experienced and entertained this new idea inside such a concept, our first response is how should we, or what should we do in order to engage with one another, to bring about its universality as a basic principle and as a must for all concerned, and how can it be any good for us, if indeed we all profoundly have separate agendas, or different ideals, as to what should, or could take precedence over the basic and fundamental needs to live out our lives, when food, and shelter, and clothing, and companionship, and a sense of self, or a clarity of awareness is needed at the very heart of what it is, to not only be, but remain humane.

As for the background, or indeed the backdrop, and the combining and dedicated efforts, that it has taken me as a writer to come to arrive at within this story of the Angel Babies, and of course the time that it has taken for me, to construct, and to collate the necessary, and if I may say worthy and worthwhile aspects, for this particular body of work to become written and completed within the trilogy of the Angel Babies, I would very much like just like to inform the readership, that upon my exploration and construction of this body of work, that I myself as a person, have experienced several variables of conversions upon my spiritual and emotional being, upon the instruction and initiation of bringing the series of these books into the light.

For had I not been introduced into the many schools of thought and allied faiths of Christianity, Islam, Hare Krsna, Hindu, Buddhism, Dao and Shinto, that it may never have transpired or surmounted, or indeed would have been very much an arduous and challenging task, to find the right motivation for the narrative, very much needed and applied, with which to find and devise the relative inspiration, and ideas explored and written within the context and narrative of the characters and the storyline that I have presented to you as an author.

~ Clive Alando Taylor